Leading Innovation and Inclusion

Strategies for Embracing Disruption
and Designing the Future Together

Marcia-Elizabeth C. Favale

Copyright © 2024 by Marcia-Elizabeth C. Favale

Book Design and Interior by Damonza

All rights reserved. This book or any portion thereof may not be reproduced or used in any manner whatsoever without the express written permission of the publisher except for the use of brief quotations in a book review.

Printed in the United States of America

First Printing, 2024

ISBN (hardcover) 979-8-9861308-4-2

ISBN (paperback) 979-8-9861308-2-8

ISBN (eBook) 979-8-9861308-3-5

Dedication

This book was written to inspire and encourage all to have a voice. You do not need to be a household name to create positive impact. You do not need to fit in an accepted box or be prescribed acceptance or even be a unicorn. Just be that voice and action that makes room for a better world.

Genius can come from anywhere.

Praise for *Leading Innovation and Inclusion*

"As an innovator introducing sweeping changes to a system affecting all citizens of a country—with wider implications across continents—Marcia Favale answered the call for help from a prime minister and flew 6,000 miles to be that unforgettable leader. Her knowledge and immense courage inspired a team of experts to quickly assemble and commit to a long-term project. But as she writes, 'genius can come from anywhere'. And these aren't merely empty words. Her strategies and stories are clear, compelling, and highly inspirational for those with the independent spirit of an inventor. This book perfectly merges matters of the head and heart when it comes to leadership and I dare say, LIFE!"
—*Bhavana Smith, Founder & CEO of Until There Are Nine, and Pay and Promotion Equity Advocate*

"Do you want to shape tomorrow's leaders? Are you going to open doors and keep them open as you pass through? Are you willing to reach back and bring someone worthy along—no strings attached? Not to give away the ending about the magic of mentorship, but being an avid one myself, I see the power of this exchange daily. With this unique book, Marcia Favale defines what it's all about, threading innovation and inclusion together in spectacular storytelling fashion—not to mention dozens of tools you can implement today. If you're one step away from the next great invention or disruption, Marcia's guidance will give you all the courage you need!"
—*Greg Morley, Cultural Competency Thought Leader and Advisor, and Author of Bond: Belonging and the Keys to Inclusion and Connection*

"Marcia says, 'Fear of diversity destroys us.' Strong words that ring true, and through leading by vivid example, she shows us what is possible across industries and across continents as the innovator that others call in the middle of the night. Brains are on full display in this treasure trove of meaningful examples. With an appreciation of all dimensions of difference, Marcia Favale is also that inclusive leader who reinforces we are not defined by our bodies—we have the power to choose who we are beyond the constraints of our external characteristics. That choice makes us limitless innovators."

—*BE Alink, CEO, Founder and Inventor, The Alinker*

"Marcia Favale holds self-awareness in such high regard that she took rare time and space to walk six hours a day to complete the Camino de Santiago, a pilgrimage that dates back to the 9th century. As she writes, 'unwaveringly to reach a destination that does not entail a bonus or applause, just a commitment to bring balance'. In the 10 strategies she offers, there is no shortage of riveting stories like this as she takes the reader along, demonstrating the power of diverse thinking and relationships to manifest at the level of ingenuity we're capable of."

—*M. Najeeb Ahmad and Scott R. Willett, Ph.D., Principals, Pennington, and Co-Authors of Surge: Change Everything with Your Rare Time and Space*

"As a former retail executive, I appreciate the diversity of skills that Marcia exhibits through her many accomplishments. In the second chapter of my career, I had the privilege of supporting a very large financial commitment to advance women-owned businesses, and through that work I met some extraordinary and resilient women in various industries. I applaud Marcia for her leadership in finance, technology, and entrepreneurship. In her book, one of the strategies she talks about is "Raise Your Voice to Benefit Others". I strongly believe in this characteristic and the subsequent actions that go with it. This book is a must read and a roadmap for becoming an intentional, inclusive leader!"
—*Michael A. Byron, Managing Director,*
Byron Diversity Business Consulting

"Not only is Marcia Favale a noted finance deal maker—she is a top deal maker in inclusive partnerships that influence great change. Her 10 strategies are power-packed, amply describing how she did it and how you can too. The opening prompts in each chapter are brilliant, helping you practice thinking about innovation and inclusion as one unifying starting point toward your goals. Authored by premier innovator, inventor, *and* interventionist, this book will be a classic in innovation and DEI!"
—*Paul Wolfe, Human First Leadership Advocate,*
Author of Human Beings First: Practices for
Empathetic, Expressive Leadership

Acknowledgments

I want to thank all the people who contributed to this book: my little sister, Maria Monica, Elliot W. Wislar, Maureen Lippe, Donna Wilson, Joel Motley, Grigory Marchenko, Ariell Ahearn Ligham, and Ludovic Phalippou. I especially thank my editor, Candi S. Cross, and Michele Francis for her insights.

Contents

Dedication . iii
Acknowledgments . ix
Foreword . xiii
Introduction: Pressure Sparks Ideas and Teamwork xvii
1: Answer the Call for Innovation . 1
2: Raise Your Voice to Benefit Others 23
3: Lead with EQ, Close with IQ. 37
4: Continuously Learn . 43
5: Be a Master Builder . 49
6: Thrive on Curiosity and Courage 63
7: Close Windows, Knock Down Doors. 71
8: Never Apologize, Always Enlighten 77
9: Accept Failure as Fire . 87
10: Master the Mentor's Magic. 95
References . 100
About the Author . 104

Foreword

Italian Renaissance Poet Petrarch said, "Sameness is the mother of disgust, variety the cure." In the 1300s, he became one of the fathers of the modern Italian language. As I consider all that qualifies Marcia to pair innovation with inclusive leadership—and teach it in this book with such finesse—I think of her as powering up a new language. One that perfectly marries two positive forces behind every great leader. Expression of thrilling, new ideas, strategies, and visions that shatter rusty molds of business models—models that are neither competitive in today's wired landscape of artificial intelligence nor fostering rich diversity of people, points of view, and planetary gifts. A lexicon of high emotional intelligence with the supreme knowledge that can only be gleaned from raw experiences as an inventor, investor, product and people manager, and sometimes lone, courageous disruptor that answers a call in the middle of the night and doesn't hang up until an international crisis is stopped.

In showing us how to lead innovation and inclusion with a world view, Marcia proves that the possibilities are endless. Her own varied background crisscrosses the globe in country and company, never putting the brakes on learning or leading with an open mind and heart. Her language is for everyone whose curiosity quiets down fear and judgment as soon as they see and sense a new idea that they intuitively know will make a difference. Sometimes that idea may be how to create a wider safe harbor for others to thrive in.

As both a CEO of an innovative investment company in the financial capital of the globe and a champion ocean racer, I'm no stranger to risk. I know a fellow risk taker when I meet her! I also know the sheer power of staying the course and making impact. One person on a mission to make the difference that Marcia has can wake up the world to the type of transformation that is boundless in its results and rewards. In the year of 2024, there are no more sidelines or silent head nods. Voice is victory!

In your hands you have ten exceptional and accessible strategies conceived by someone you can trust. Marcia takes us on her intriguing journey along the way so we can use courageous inquiry, bold insight, and inclusive practice to shape our own. If you have an idea that you know needs to be wrestled out of the rough water, protected, and carried to the shore for other eyes or simply long

for a more innovative life, you've found your amazing, inspirational coach.
—*Elliott W. Wislar, CEO of Clearbrook, and Author of Voyage to Victory: Stories and Strategies for Resilience, Risk and Reward*

Introduction
Pressure Sparks Ideas and Teamwork

"If I didn't define myself for myself, I would be crunched into other people's fantasies for me and eaten alive."
—*Audre Lorde, author and civil rights activist*

What do you do when a compelling idea flickers in your mind? Do you create beautiful poetry, turn a pearl into a whole string of pearls, spring out of bed and type 10,000 words? Do you call your trusted calvary (assuming you have one) to help you establish a plan of action that will set the world on fire with your invention, innovation, or intervention?

Those ideas popping in your mind have significance. They are meant to manifest or at least nurture your creativity, your understanding of the world, and our collective ingenuity. They are never a waste, never worthless.

Even though I am not a household name, my innovations have impacted international banking and are disrupting digital advertising to the extent that some leading platforms are imitating aspects of my design. As they say, "Imitation is the sincerest form of flattery." My interventions as a board member have changed perceptions and created sustainable inclusivity, impacting lives. *Leading Innovation and Inclusion* is written to inspire the everyday unsung heroes and those yet to be noticed to 'go for it' while forging a path that leverages diversity, equity, and inclusion. Genius can come from anywhere.

As a baseline, the *innovator* is: One of the 627,000 entrepreneurs who opened a new business in the U.S. during 2021 amidst a pandemic. The woman who aggressively went after and received investor funding, not swayed by the dismal "1 percent approval" of funding going to women's businesses in our modern age. The junior, perhaps shy, person who devised and presented a unique program for her department. And innovators are those who did not quite make it but DID IT! The inclusive innovator engages and inspires others to electrifying heights, not just an encouraging step toward an opportunity.

In "Diversity's Positive Impact on Innovation and Outcomes", a captivating study by Coqual (formerly Center for Talent Innovation) and Hewlett Consulting Partners LLC, the link between innovation and inclusion

is strikingly poignant. One key insight from the report that could encapsulate every example in this book: "A lack of diversity in leadership can mean groupthink and hinder an organization's ability to respond well to a novel situation where innovative thinking is required." You will read in Chapter 1 how I sidestepped groupthink and forged a new way of thinking during the financial crisis or changed the culture of a board. Or, how I went for it and created a software company against all odds and became a tech inventor with patents in the U.S., China, UK, the EU, and Kazakhstan.

Coqual also defines "diversity dividend" in its research: "Inherently diverse employees—with inherent diversity referring to an individual's gender, race/ethnicity, age, religious background, socioeconomic background, sexual orientation, disability status, and nationality—can be founts of insights that can help new products match the market….when teams have one or more members who represent 'otherness' you widen perceptively your sphere of influence and addressable market. A team that understands its target user may be more likely to perceive issues unique to that user, and to hone in on solutions that address those issues. As a result, that team may be more likely to come up with ideas for unmet market needs. Ideas to serve new markets, however, are merely a first step towards the creation of value. To fully innovate, organizations must develop these ideas and deploy them

in the marketplace. That process requires decision makers' buy-in and endorsement. In many larger companies, this endorsement must come from powerful leaders scattered throughout divisions and ranks." The research backs up the need for leading innovation and inclusion. Some of us already have the intuition, values, and mission-driven purpose for it.

All statistics and sophisticated evidence aside, it's never easy to change, invent, or disrupt. Forgive my candidness here, but some people want you to fail. Simply put, you will threaten groupthink, business models, and people's personal and professional identities. So, when they come for you, flip their intentions into pools of strength. If they told you of resistance, shadows, and barriers—good! Their lack of support serves to teach you something new and strengthen your resilience in the face of resistance, even danger. For example, facing the dangers of the COVID-19 pandemic and global humanitarian crisis, what did you take stock of in your life? Did you develop a new way of thinking? Did you capitalize on bursts of inspiration? Some budding entrepreneurs reimagined and reinvented their playbook and created a competitive advantage in a product or service category that others couldn't get ahead of. Some individuals wrote gorgeously crafted stories during quarantine that are the basis for books, plays, musicals, television shows, and films. Some companies created more value and exercised more empathy in a frantic attempt

to retain people. Some communities rallied together to crowdsource goods and services through listservs, or as we saw in heartwarming videos, announcements shouted from balcony to balcony. *This* is inclusive innovation.

Simply put, *innovation* can be a new idea, product or method that is translated into goods or services that create value or for which customers are willing to pay. However, payment is not the only metric. The essence of innovation is improvement—the ability to create something better and launch it to the world. If your creations will ultimately help others, what is there to fear on the journey? Remember that fear takes time. You are required to invest time and energy in fear in order for it to have any kind of meaning. Do you have these hours to spare or the emotional stamina to devote to fear? If you are like me, you want your hours to be spent in intentional alignment with your gifts and mission.

Psst! Don't confine yourself to a size that makes others feel larger. Occupy that space. Dress it up to resemble your influence. Because let's face it: Day-to-day mediocrity is not routine for a leader of innovation and inclusion, even if you are on the full agenda of life. I am a mother and make no excuses for loving being a mother more than anything. I am also a woman whose eyes see limitless possibilities, heart feels passion and fascination, with a drive and a desire to devise strategies and execute. I am a

woman who loves taking risk, but I am not reckless. So, of course, I grapple with fear, but it does not win.

The strategies in this book are built on **courageous inquiry** (learning, reflection, comprehension) that leads to **bold insight** (where awareness meets strong desire to act), propelling one to an **inclusive practice** (action) of embarking on the innovator's journey.

1
Answer the Call for Innovation

"The big talent is persistence."
—*Octavia E. Butler, science fiction author*

> **Courageous Inquiry**
>
> How will your innovation, invention, or intervention impact others?

Bold Insight

Don't lose sight of the impact or your audience and what they will experience from your product, service, or method. The journey can get bumpy. Stay informed of your audience's needs and any factors impacting those needs throughout research and development. Discern what is positive against that which is expedient. Who are you serving, really? Is your addressable market ready?

Innovative Practice

1. When an idea gels, don't put off recording it on paper or via audio. (Ideas come and go like other thoughts.)

2. Probe the landscape of your topic: audience, needs the subject matter will meet, competition, marketability, and risk analysis.

3. Who and what will it displace or threaten?

4. Package and organize your findings in a unique place that allows you to solely focus on the innovation journey.

> 5. Learn to love the word, *no*. The more people tell you that you will fail (and why and how), the better. They are providing you with the roadmap to the destination you want to avoid.
>
> 6. Never be timid in asking for what you need to be successful.

Caroline Howard, writing for *Forbes*, distinguishes between innovation and disruption: "They are similar in that they are both makers and builders. Disruption takes a left turn by literally uprooting and changing how we think, behave, do business, learn, and go about our day-to-day." Harvard Business School professor and disruption guru Clayton Christensen says that "a disruption displaces an existing market, industry, or technology and produces something new and more efficient and worthwhile. It is at once destructive and creative." On the other hand, innovation "for its part, can refer to something new or to a change made to an existing product, idea, or field."[1]

Ultimately, an innovation can be disruptive. Settle in while I tell you an over USD$30 billion tale about disruption that came after a series of "no's" that escalated to a momentous "YES!" eventually.

[1] https://www.merriam-webster.com/dictionary/innovation

Creating an International Benchmark During the Financial Crisis

In 2006, my friend, Joel Motley, was asked by World Bank to go to Kazakhstan to help the government think about infrastructure finance and create a bond market, which they didn't have. The Soviet Union collapsed, and the region became the biggest land mass, which ignited the discovery of oil. Suddenly it was a bonanza. But the finance infrastructure was new and fragile.

Joel had spent twenty years as an advisor to state and local governments in the U.S. He was always interested in utilizing the same skillset for emerging market countries abroad. Carol Brookins had just stepped down from World Bank as executive director in 2005 and they started a company to provide advice to emerging market companies. Carol enlisted Joel to be a part of the group in Kazakhstan. It was an eye opener for him, as he had never been east of Italy.

Joel picks up the story here: "It was the Wild West. It was a wild scene with fast land areas, and new oil wealth, like when the U.S. made their discovery and Rockefeller rose. It was roaring capitalism, but it was also scary because it was brand new. No strong legal systems or regulations. There were so few guardrails. I would not have been able to fare well in that environment."

Fast-forward. Easy money conditions evaporated following the Lehman Brothers collapse in 2008, increasing refinancing risk and causing liquidity shortages throughout the financial system including capital markets. Some countries, companies, and banks couldn't go to the market to refinance. Bankruptcies, liquidations, and restructures exploded. Sheer panic echoed across global markets, and Kazakhstan in Central Asia, was not immune. This amazing country, the ninth largest territorial country in the world, blends ancient elements and modern amenities. It is a geo-politically important country as it balances its existence between Russia and China whilst embracing Western culture.

My Kazakhstan journey began in 2002. I was working at global financial services firm UBS London as the head of CEMEA (Central Europe, Middle East, and Africa) corporate bond research. The Development Bank of Kazakhstan was interested in doing a hard currency Eurobond, an international bond that is denominated in a currency not native to the country where it is issued. This would be the first for the country, opening a new market. As part of the opportunity, I was also able to elevate a young woman's capital markets career. Until then, she was met with resistance by other seniors who did not accurately assess the potential of developing a market in Kazakhstan. She asked; I made the time. The rest is history.

In the years leading to the financial crisis, Kazakhstan enjoyed many years of investor interest with the banks becoming prolific issuers. Research departments frequently showcased Kazakhstan as having a strong—and in some expert opinions, the *strongest*—banking systems in the Commonwealth of Independent States. When refinancing became difficult, it was revealed that the sector was over-levered. Dependency on the international capital markets during this period was a vulnerability further exaggerated by the fact that Kazakhstan did not have a developed domestic capital market.

Deteriorating asset quality and the devaluation of the Kazakhstan currency (KZT) further pressured banks' balance sheets. At the height of the crisis, BTA Bank, Alliance Bank and Temir Bank needed recapitalization. Their balance sheets reflected the effects of closed capital markets, the economic slowdown, and poor risk management. BTA Bank, the largest in assets, was of particular concern given the impact that its disorderly collapse could have on the banking system.

When Grigory Marchenko, the governor of the National Bank of Kazakhstan, asked if I would help, I took the call and the challenge that came with it: help Kazakhstan figure out what to do next. Marchenko, a towering personality in finance, explains the landscape in my first book, *Risk, Recovery and Empowerment: The*

Kazakhstan Bank Restructure Case Study: "I was appointed for my second term as a governor of National Bank of Kazakhstan in late January 2009, to tackle two large problems at once: 1. Our large neighbor and our largest trading partner then, Russia, devalued its currency, the ruble, by 50%, and we had to do a compensatory devaluation to protect our markets. The tenge had fallen by 25% on Feb. 4, which was hugely criticized at the time, but proved to be a timely and efficient measure. And 2. We knew that at least three of our ten largest banks would be hit hard by the devaluation as they had clearly over-borrowed in the international capital markets during the boom years (2005-2007). Over 60% of BTA Bank and Temir Bank liabilities and over 70% of Alliance Bank debt was in foreign currencies. We had to either restructure their foreign debt or liquidate them in an orderly manner. The third option—bailing them out by the state using taxpayers' money (which was a heavily preferred option in the West)—was briefly discussed, but the ticket price was way too heavy for the state."

How did such an opportunity manifest for me? This distinguished request came because of establishing relationships while working for UBS and overseeing the first Eurobond deal for the Development Bank of Kazakhstan. These key relationships continued while I managed money for Brevan Howard, a leading global hedge fund, and Advent Capital Management, an asset manager. I had unique insight.

I understood fully the value chain of investing not only in the emerging markets but also, in Kazakhstan, having been on the sell side and buy side. I not only helped issuers come to market and then covered them, providing *buy* and *sell* recommendations (sell side) to asset managers, but also, I went from the sell side to the buy side (investing in the securities).

Within hours of arriving in Astana, the capital of Kazakhstan, I was ushered into the newly merged Samruk-Kazyna conference room where I was briefed on all the issues pertaining to the banks, the sector and economy. I had to process all this new information and organize an approach within twenty-four hours. The ultimate decision maker was the prime minister, who I had never met. Complicating matters was the alleged fraud perpetuated by the former chairman of BTA Bank[2], along with relentless investor and market pressure. Germany, the United States, and other creditors were pressuring Kazakhstan. As Governor Marchenko explained in an article by *DK News* detailing her historical visit to discuss trade and investment, German's Prime Minister Angela Merkel wanted Kazakhstan to return all the money owed by BTA Bank to Germany, at the expense of the National Fund, and separately, a representative of the US EXIM Bank promised to send marines. Marchenko stated, "The first

2 https://www.inhouselawyer.co.uk/legal-briefing/the-chronicles-of-the-jsc-bta-bank-litigation/

conversations with representatives of export-import banks and agencies were very tough. They said that BTA had a debt of $20 billion, and the National Fund of Kazakhstan would easily cover these obligations."[3]

I had to figure out if the government of Kazakhstan should adopt the sovereign bailout approach implemented by the developed economies, as pitched by the global investment banks, or if an innovative alternative could be implemented. I chose the innovative alternative, and in the process, created a benchmark, the Burden Sharing Framework.

The newness of the approach was that it was a 'bail-in' and not a 'bail-out' keeping investors as partners in the process of recapitalizing and restructuring the banks. This meant that Kazakhstan did not have to write a huge check to bail out investors and therefore, would not add to its debt profile that could have threatened its investment grade rating. It also meant that some investors would incur substantial losses.

I pitched the framework to the National Bank governor and prime Minister, and they agreed. By accepting the Burden Sharing Framework, Kazakhstan risked the ire of investors but protected the national economy by not depleting the national fund. Accepting this new approach

[3] https://dknews.kz/ru/eksklyuziv-dk/307368-grigoriy-marchenko-my-delali-svoyu-rabotu-horosho

was not easy. It broke the mold of how investors wanted to be treated. It created a new paradigm. It took vision and the desire to do the right thing versus the expeditious and less risky one. As Marchenko stated, "Who will large foreign companies protect? That's right, those who provide them with a constant flow of funds." Kazakhstan was not a recurring client. These are the investors that trade and do business with the investment banks daily. Government understood that I would fight for their interests without conflicts of interest. This clear return of power to Kazakhstan, by accepting the Burden Sharing Framework approach, minimized the power of global investment banks. It put them on the bench. It was a courageous stance by the government.

The next leap of faith by the government was in believing in my ability to execute. I was known for my expertise and integrity and of course, knowledge and skillset. But my ability to lead change—in fact, complex change management at this global and visible level—was not known.

Looking me straight in the eye, the prime minister asked what I needed to be empowered to implement the plan. I responded I would need to be vested with authority to execute and not be circumvented, along with the ability to fully control the narrative design. I would also need the ability to hire strong international and domestic teams that

would follow the playbook, or risk being fired (that did happen to a global leading bank). I received the full backing of government for authority and executing the mission. Soon thereafter, I was made senior advisor to the prime minister, by a decree and independent restructuring advisor.

As Kazakhstan's approach was gaining interest and the world was searching for the best way to tackle the affect of the financial crisis on capital markets and financial institutions, thought leaders were curious about what Kazakhstan was doing. What was this new course of action? Why were they not following the playbook? Placing myself in front of these questions, I took the opportunity to describe the Burden Sharing Framework to the world. Filling the knowledge gap created the opportunity to present and interact with finance powerhouses such as Thomas Mirow, former president of the European Bank of Restructuring and Development (EBRD), and Dominque Strauss-Kahn, managing director of the International Monetary Fund (IMF), who I met in a hotel lobby flanked by his entourage. As I explained why we were not taking IMF money, I also met James Wolfensohn, former president of the World Bank Group, who kindly flew me back to New York City from Astana on his private jet. All tipped their hats to my *hutzpah* and wished me luck, with perhaps the expectation that I would be coming back soon for assistance. That did not happen. I even had the pleasure of explaining to a United States congressional delegation

led by Minority Leader John Boehner our approach and how it differed when compared to the practices adopted in the United States and globally.

I will not use the words, "unreal" or "unimaginable", to describe the events that ensued, since inclusive innovators prove that *everything* is real and imaginable. Nonetheless, it was colossal. My strategy, which now had buy-in, needed an operational framework promoting transparency and integrity of process for success and a powerful narrative design. You can disrupt and innovate transparently. You can and must be comfortable operating outside your skillset. Enlist help. Build a team but never give up your stewardship and leadership. Be the captain and the coach.

Operating Outside of Your Skillset

I am not a lawyer, but I got a law passed in Kazakhstan. I knew that a law was needed to bring transparency and legitimacy to the restructuring process. So, I mobilized a law firm to advise on how to write the law, and as a result of this initiative, the 'cramdown law' became part of Kazakhstan's legislation. Imagine—having a law passed! To quote from my book, *Risk, Recovery, and Empowerment: The Kazakhstan Bank Restructure Case Study*:

> The restructuring process framework and principles were announced to investors early in the first quarter of 2009. To ensure a successful

execution, recognized financial and legal advisors were hired in the first quarter of 2009 for the restructuring process, and in the second quarter of 2009, the asset recovery team for BTA Bank was in place.

As part of the government's objective to provide a transparent and fair legislative framework to the restructuring process, it elaborated the "New Restructuring Law" to ensure that a restructuring effected under it would be capable of international recognition in countries (e.g., United Kingdom, United States) that have adopted legislation based on the 1997 UNCITRAL Model Law on Cross-Border Insolvency.

The legislative package was contained in the Law of the Republic of Kazakhstan No. 18S-IV ZRK dated July 11, 2009, on Amendments and Additions to Certain Legislative Acts on Money Payments and Transfers, Accounting and Financial Reporting, Banking Activities, the National Bank of Kazakhstan, and Other Legislation (the New Restructuring Law), published in Kazakhstanskaya Pravda on July 30, 2009, and taking effect on August 30, 2009.

I also created a new way of looking at trade finance by devising and instituting the process of discernment regarding *true trade finance*. This is a massive market and has many players including governmental agencies. So, taking on governments and multi-laterals and convincing

them that the industry needs to reset was not part of my skillset at the time. But it was achieved, creating a new language, and now, the industry speaks of true trade finance within the parlance of trade finance (in other words, the financing of international trade).

Build Your Trust Treasure

I had to become familiar with government affairs and the people operating within the system, and several figures became lifelong friends. If you are tasked with seeing through innovation—the creation of something that has never been done before—people must trust you. You must have integrity and humility to be able to listen without pride and arrogance and be accessible. One can listen and still stay the course. Even if people agree to your innovation, people must see you as the leader of innovation and inclusion in order to support the original idea that has never been enacted before. The minute they back you, especially when breaking the norm, they are vulnerable.

"Trust is a conviction that is built slowly, through repeated interactions that take place over a long period of time," states organizational behavior researchers Alisa Yu, Julian Zlatev, and Justin Berg in their piece, "What's the Best Way to Build Trust at Work?" in *Harvard Business Review*. Their advice is informed by six studies in which they looked at the role emotional acknowledgment, or the

act of verbally recognizing someone else's feelings, plays in a wide variety of high- and low-stakes situations—from employee socializing in a break room to hospital workers navigating intensive care units. Drawing on the *costly signaling* theory, which states that small gestures can make a big impact, they aimed to discover how emotional acknowledgment influences interpersonal trust. Simple gestures are effective. During the negotiations, birthdays were celebrated, even if only to pause the negotiations with a celebratory glass of champagne. Accessibility is key. Listen to frustrations as you would to praises. I routinely had the same people that were fighting against the restructuring terms, personally and privately, were wishing me success against their corporate interests. Why? Because it made sense and they themselves would want the outcome if they were not chained to the corporate mission. Therefore, I had to foster open communication and confidentiality. I also had to engineer an environment that naturalized instant feedback, and promoted ethics and equity so that the new paradigm could take hold. After all, this was a new approach—and one that would directly impact bonuses and business models. It was personal.

In the spirit of open, consistent, and transparent negotiations, I was known to tell journalists to "record me". As such, the restructuring was widely covered in *Financial Times*, *Wall Street Journal*, *The Economist*, *Reuters*, *Bloomberg* and many more. If I ever misled in

my comments or interviews, it would be out there in the public domain. I was constantly being tested due to both the gravity of the challenges at hand and as the unique spokesperson. Needless to say, there were no false reports. People may have disagreed or even fought against me, but they trusted me, and that makes all the difference.

It's worth noting that *Oxford Research Encyclopedias* defines *interpersonal trust* as: the perception you have that other people will not do anything that will harm your interest; the individual is giving the willingness to accept vulnerability or risk based on expectations regarding another person's behavior. Vulnerability and risk consistently power the engine of innovation—and relationships.

As a by-product of innovation and success, one needs to be aware that you will be subject to envy and sabotage, as you 'create and implement'. They feel that your intelligence and/or ideas threaten their business models and professional impact. Some will covet and hijack your innovation—envying your mind, leadership, and achievement—and bemoan your success. They will take it personally. Not your problem. Such is life! Move on and never become this lesser person. I can list people and institutions that have acted in this manner, but I will take the higher road. As Michele Obama said, "When they go low, we go high."

Art and Science Behind Invention

The basis of how I came up with breaking the international finance standard is simple: I didn't believe that professional investors, who are paid handsomely for professional investment acumen, need to be bailed out at the expense of funds that need to go into schools, logistics, things that have an impact on everyday lives (especially during a crisis like the global financial meltdown). I didn't understand why the government would have to take on the burden of poor management, market dynamics and alleged fraud and bail out sophisticated investors who have an army of people feeding them information and who get paid handsomely (typically 2% management fee over assets and 20% of returns) for their analytical and investing skills. I questioned bailouts and asymmetric payments. Call it "conscious capitalism".

As the new Burden Sharing Restructuring Framework was taking hold, investors started to make threats. Stating that Kazakhstan was a relatively small emerging market economy, the investors threatened to close capital markets. Kazakhstan would be a pariah. These investors were not successful. We were able to issue a quasi-sovereign at a better price than before the crisis. Credit rating agencies did not penalize Kazakhstan. In fact, the rating agencies kept the investment grade rating of the country. The market was catching on that our strategy was actually better for Kazakhstan.

The IFC (International Finance Corporation), which was founded in 1956 and has invested more than $321 billion in emerging markets and developing economies, has frequently talked about Kazakhstan getting it right, citing the importance of the novel role of the independent advisors. In addition, indisputable financial data sources followed and verified the story, including *The Economist*, *Euro Money*, *Financial Times*, and *Global Trade Review*.

One publication deemed me "a woman against investment banking". Although flashy, that was far from the truth. The proposals provided were not benefiting the client but rather, the recurring clients, those that are the everyday revenue generators for the investment banks. Instead, the new framework protected Kazakhstan and the financial system and made investors and the banks partners in the restructuring, then ongoing. We were successful and in fact, I consider it a compliment that investment bankers hijacked what I did (taking credit and attempting to box me out of the frame) and brought it to a larger discussion within Europe. Unfortunately, some investment banks continued to scare emerging markets thinking of implementing the same framework by stating it "only worked for a small economy". Funny that the threat to follow their prescription was exactly the opposite.

What makes the Kazakhstan restructuring of note is that most restructurings across Europe have focused a sovereign

bailout through guarantees or substituting private debt for sovereign debt. Consequently, sovereigns have been laden with debt, having to implement unpopular austerity programs such as:

- Revenue generation (higher taxes) to fund spending
- Raising taxes while cutting nonessential or essential government functions to cater to investors
- Lowering taxes and lowering government spending
- Minimizing moral hazard with incentives, policies to prevent immoral behavior and regular monitoring
- Keeping the investment grade sovereign rating
- Improving corporate governance

Land of Drastic Disruptions

After devising and implementing the Burden Sharing Restructuring Framework that later was analyzed by the European Union (EU) restructuring discussions, I created another innovation: The People's IPO (Initial Public Offering) Programme.

As I described for *The Business Year* in 2012, the value proposition of the program was the establishment of a

wealth conduit for the people of Kazakhstan to have the opportunity to share in the growth of the country's leading companies and assets. I stated in *The Business Year*, "The People's IPO should not be compared to the privatizations of the past. Kazakhstan is approaching this program from a position of economic strength and not from a need to attract capital to plug a hole. It's a structural initiative of the government, aimed at developing the domestic capital markets, to encourage an internal investment culture, and thus provide an avenue of wealth creation. In the long term, it is intended to encourage and ultimately diversify economic activity, which will benefit all Kazakhstanis."

The objective was to make this a true People's IPO, and thus, engage individual as investor partners, developing the domestic capital markets. Disappointedly, some powers at-be sabotaged the People's IPO to rob the everyday people from participating in wealth building. They operated under a zero-sum game framework. Their actions cost the country a whole generation of growth.

We will explore messaging further throughout and explicitly in **Strategy #8: Never Apologize, Always Enlighten**. Here, note that as an innovator introducing sweeping changes to a system affecting all citizens of a country, and possibly wider implications across continents, for example, authenticity, brevity, and clarity in your communication is not a luxury; it is a necessity for buy-in

and zenith of your innovation. And keep in mind that you are always leading and serving as a role model while using the power of your communication in voice and body language.

Besides how to undertake a major project like financial restructuring, here is what I learned about answering the call for innovation:

- Your brain is designed to solve, innovative, and disrupt. Draw from experience and intellectual curiosity to always lead.
- Answering an unexpected call for your skills is representative of someone's belief in you as an innovator.
- Courage and preparation are cornerstones of innovation, which requires a want to keep learning.
- Though your ideas and intelligence may be a threat to others (even those who will ultimately benefit), stay the course in seeing your innovation through.
- Be sure to select team members who may share your principles and values but are diverse in skillset.
- When you are scared, remember how far you've come. Remember that people believe in your ability and/or envy your ability (still a compliment).

- Be aware of your limitations and plug the holes along the way.
- Keep to the authenticity of your mission and goals.

2
Raise Your Voice to Benefit Others

"Remember that no one has your unique perspective. Bravely share it. Your words may lead to an influential decision or your own next phase in life as a dynamic leader. And we could all use another outstanding leader walking the planet in these moments."

—*Tricia Brouk, from The Influential Voice*

> **Courageous Inquiry**
>
> Are you avoiding a conversation or important speech to a larger group?

Bold Insight

Speaking up is the root of change. Everyday innovators speak up to initiate improvements rather than simply criticize existing circumstances.

Inclusive Practice

1. Think about your values or purpose with every decision you face, including the decision to speak up. Do they correlate or seem disjointed? If they appear to be disjointed, you may be spending time on items that aren't priority.

2. Listen for your inner voice. If it persists on the same message track, its insistence may mean that you shouldn't hesitate any longer.

3. Assess if your hesitation or avoidance is linked to a worst-case scenario in your mind and how likely that is to occur. Try rating it 1-5, with 5 being "very likely". It's proven that most worst-case scenarios are unlikely to occur. If you rated it below 5, raise your voice. If you rated it a 5, find ways to mitigate the risks—perhaps go over the "no's". Imagine other constructs, ways, or times to impart your message or solution.

> 4. In the Oxford Women's Leadership Development Online Programme, I state, "You don't have to emulate male characteristics to be a leader." Accept your authentic self as an original leader using your qualities that may, as a woman, include trusting your instinct in an uncompromising way, resilience, adaptability, grit, tenacity.

The greatest reward of everyday innovation is making a difference.

By taking the risk that tried to terrify you into paralysis, you exercise your courage core. Courage blossoms into confidence for the next round of innovation you're tasked with, along with exciting people enough to buy in. With practice, your voice is authoritative yet calm, passionate yet inviting. Inspire!

Conquer the Podium

Communicating truth and ideas adds to the knowledge pool and stirs up everyday innovation. Every voice is meant to be used as a vehicle for change—and it doesn't have to be gigantic. It can be the words of a profound whisper sometimes. With this attitude, you never know where your next proclamation will be featured.

For instance, do you know how to earn honorable mention in the Public Library of US Diplomacy on WikiLeaks? As an inclusive innovator, you may not avoid it—as long as you're in a room of policymakers talking about highly classified information on a Saturday afternoon. My name is noted at the end of an "authorized but unsent" cable titled, "KAZAKHSTAN: PRIME MINISTER BRIEFS BOEHNER CODEL ON ECONOMIC AND ENERGY ISSUES".

> Classified By: Ambassador Richard E. Hoagland, 1.4 (b), (d) [passage] I Rep. Walden (R-OR) asked the Prime Minister if the government had an exit strategy for the financial crisis. In response, he said, "I thought you would ask me about that!," turned to his left, and summoned to the table Marcia Favale-Tarter, a Western banking advisor who owns her own consulting firm and regularly advises the Prime Minister and the Chairman of National ASTANA 00001365 004 OF 004 Welfare Fund Samruk-Kazyna, Kairat Kelimbetov. Favale-Tarter, who clearly has the Prime Minister's confidence, explained the government's plans to the delegation.

It's dated August 10, 2009, addressed to such as entities as the CIA, European Political Collective, the Defense Intelligence Agency, and the South and Central Asia Collective. I remember this day thirteen years ago and though the impact for me may be distant, the credibility,

capabilities, and competence it hints at—the social proof—remains. This is very important for every innovator since social proof denotes results you've helped someone gain. By the way, you can always devote time to develop this facet of your business.

The reality is that narrative about us, our achievements, failures, greatest loves, our children, or what we wore yesterday, exists in so many different platforms, but we can only stay ahead of so much in an around-the-clock news (or pundit) cycle. The press will always be there. How do you reach a broad audience? Make it a point to readily take on speaking opportunities, whether on a massive stage or at a small networking event. In this way, you can use the power of your voice to raise others.

I have found it to be invaluable to zero in on this type of narrative vehicle. At a conference or other industry event, you have a captive audience with the same interests, at least for that hour or longer. This is not the case in a "four-minute read" as many publications online flag these days. Can the message I share empower another person? How can my insights benefit others? Will the message inspire? Will it motivate an action that has been stifled for too long? Remember, in these forums, you also have presence and body language to add to your impact and influence.

Sharing Your Voice Is a Victory

I was invited to be part of panel at the 2010 Paris Club. Paris Club creditor countries generally meet ten times per year. Each session includes a one-day meeting known as a "Tour d'Horizon" during which Paris Club creditors discuss debt situations of debtor countries, or methodological issues regarding the debt issues more broadly, and welcome approximately 150 people.

Kazakhstan was invited by The Paris Club organizers to present the Burden Sharing Framework that was making waves through financial circles. The prime minister could not attend, so he asked me to represent Kazakhstan. Another call to answer! If you told me I would present at the same conference as international economists and policymakers and in front of Madame Christine Lagarde, who, at the time, was the French minister of economy, industry and employment and is now the president of the European Central Bank, I would raise my voice to ask, "When?" So, instead of wasting a thought on *how I got there* or *why I was chosen*, I said yes and embraced the acclaimed success of the Burden Sharing Framework that got me there.

In the reflective darkness of the room and the intense spotlights, I still remember at the end of my speech, the smile and nod of approval by Madame Lagarde, ever so subtle, but nevertheless meaningful. That selfless

encouragement has stayed with me until today. Because I stood up and delivered, I was invited to contribute to The Paris Club's annual report for which I wrote the section, "Breaking the Mold", which was well-publicized.

When you find yourself networking in the center of world shapers, answer the call and meet the opportunity! Welcome success. Welcome alliances. Welcome ways to teach and shape. Welcome attention that puts your effort to the test. Welcome the power of listening without ego. It's all part of the cycle.

If you are not yet on the world stage, there are so many networking groups to associate yourself with and ease into your talking points, honing your skills, in smaller support systems. For example, at the onset of the pandemic of COVID-19, large multinational companies like Dell and Microsoft started groups that brought together women entrepreneurs and executives to share business advice and resources. It was a lifesaver for so many who were now working from home and battling isolation and disconnect from teams and brainstorming sessions that had been in person. Above all, these companies spearheaded a platform of ready connections and opportunities in such a challenging time worldwide. The power of groups like Microsoft Women Community cannot be understated. Their recent "Inclusion Is Innovation" content platform features success stories depicted in beautiful photography,

videos, and narratives. The group shares advice and inspirational stories related to STEM, gaming, cultural transformation, product marketing, data and AI.

By all accounts, not simply in messaging, the company is a bona fide leader of innovation and inclusion, recently sharing the following data to back it up:

- *Influencing progress*—Microsoft has been a signatory to the UN's Global Compact Women's Empowerment Principles since 2010, committing our corporate action to the global advancement of women in the workplace, marketplace, and community.
- *Invested in equity*—At Microsoft, US women employees earn $1.007 total pay for every $1.000 earned by employees who are men and have the same job title and level and considering tenure.
- *Increasing representation*—Women make up 31.2% of the core Microsoft workforce worldwide, up from 27.6% in 2019. The representation of women in executive roles is 29.1%, an increase of 3.2 percentage points year over year.

Cycle of Learning and Leading Change

When I was accepted into Oxford Saïd Business School, I did not foresee that an "Oxford Case Study" would be written

about my achievements in Kazakhstan during the financial crisis-shaping curriculum. When Professor Atif Ansar and his research assistant, Ariell Ahearn Ligham, approached me to participate in a "teaching case" on the financial restructure, I agreed. This was a great notch in the cycle of learning and leading change and an opportunity to be a role model for both women and men. From numerous meetings, Atif and Ariell managed to write a thirty-five-page narrative that has become an exemplary teaching case used around the world.

Ariell was in the final year of her degree, with a focus on working with nomadic people in Mongolia. She understood Kazakhstan because of the location and history. With a teaching case for Oxford Saïd Business School, an individual is the protagonist in the story, and students must decide what's best for the situation being presented. Ariell explains what made this an uncommon addition to Oxford teaching cases:

> It's not very easy to work in Kazakhstan. A lifelong president was in place, like a benevolent dictator, who had a lot of control over the political situation there. It's not often you have someone from the West to work with this kind of country with such ease, joy. Marcia convinced them to follow her guidance, the prescription she was trying to give. She repaired the entire financial system because they were going through a huge meltdown. It was an equivalent to a major financial institution. I thought: How does a

woman get results in this environment with powerful men? She's the type of person who could go to any place, like Saudi Arabia, and switch mindset and to do the right thing. She has a moral code and an ethical code behind her. After we finished the case, she came back to teach Oxford executive business students. She has a commanding presence and doesn't take crap from anyone. But she's also nice. It was a formative time when I was trying to figure out what to do next. She's an example of making you want to have confidence to do your own thing rather than waiting for someone to hire you. Build your own world. You don't have to be selected. You can do something on your own.

In Adam Grant's book, *Originals*, he writes, "Years ago, psychologists discovered that there are two routes of achievement: conformity and originality. Conformity means following the crowd down conventional paths and maintaining the status quo. Originality is taking the road less traveled, championing a set of novel ideas that go against the grain but ultimately make things better." Since "nothing is completely original," he goes on to give his own definition, which resonates: "Originality involves introducing and advancing an idea that's relatively unusual with a particular domain, and that has the potential to improve it."

To be heard, to tackle and win the podium, you need to constantly negotiate.

Negotiation: Showcase Your Originality

There are secrets to negotiation. Treat negotiation as both courageous conversation and a coaching device. Interject determination and exhilaration. There should be infectious enthusiasm that translates across the cultures of the group, along with a tone that coaches (teach, ask for feedback, practice deep listening in which you are internalizing the feedback and then reflecting it back). Get away from the notion that negotiation is a mechanical step in your innovation efforts. Negotiation requires creativity and the ability to balance IQ with EQ.

Harvard Law School's Program on Negotiation openly shares the following tips for strengthening your negotiation skills to improve your outcomes:

1. Analyze and cultivate your best alternative to a negotiated agreement (BATNA). In both integrative negotiation and adversarial bargaining, your best source of power is your ability and willingness to walk away and take another deal.
2. Negotiate the process. Don't assume you're both on the same page when it comes to determining when to meet, who should be present, what your agenda will be, and so on.
3. Build rapport. You and your counterpart may be more collaborative and likely to reach an

agreement if you spend even just a few minutes trying to get to know each other.

4. Listen actively. Once you start discussing substance, resist the common urge to think about what you're going to say. Acknowledge difficult feelings, like frustration.

5. Ask good questions. You can gain more in integrative negotiation by asking lots of questions—ones that are likely to get helpful answers.

6. Search for smart tradeoffs. Try to identify issues that your counterpart cares deeply about that you value less. Propose making a concession on that issue in exchange for a concession from her on an issue you value highly.

7. Be aware of the anchoring bias. Ample research shows that the first number mentioned in a negotiation, however arbitrary, exerts a powerful influence on the negotiation that follows.

8. Present multiple equivalent offers simultaneously (MESOs).

9. Try a contingent contract. Try proposing a contingent contract—in essence, a bet about how future events will unfold.

10. Plan for the implementation stage. Place milestones and deadlines in your contract to ensure that commitments are being met.

I know whether deliberately and innately or not, I

have implemented several of these negotiation techniques. By nature, I am diplomatic and firm. Working toward inclusion of others' thoughts, ideas, dialogue, and objectives, no matter how divergent from your own, already encompasses much of this negotiation power book—thank you, Harvard!

The soft skills of an inclusive innovator are equally important. The former chairman of the Management Board of the Development Bank of Kazakhstan says: "We always get high inspiration from Marcia because of her incredible background. She's always open, receptive, and responsive. She's always ready to benefit our country." The emphasis here is that his words simply reinforce that I raised my voice to benefit others. They also portend to never underestimate the power of your emotional intelligence (EQ), which we will explore next.

3
Lead with EQ, Close with IQ

"I PAY NO ATTENTION WHATEVER TO ANYBODY'S PRAISE OR BLAME. I SIMPLY FOLLOW MY OWN FEELINGS."
—*Wolfgang Amadeus Mozart, composer*

Courageous Inquiry
Do you have a high level of awareness of your strengths and weaknesses?

Bold Insight
Having a high EQ signifies that you know your strengths and how to optimize them while using discernment and keeping your weaknesses from stopping you from your next action.

> **Inclusive Practice**
>
> 1. Negative thoughts can be perceived as threats, which increase your stress level and ultimately, break down your body. For the "bad" occurring, think of what can be learned or improved from the situation. This thought pattern offers hope, contemplation, aspiration vs. the downward spiral of dwelling and sinking.
>
> 2. Disconnect and take regular time off. Intellectually, we know that all living creatures need rest. Innovators are no different!
>
> 3. Use the vocabulary available to describe your feelings. You will earn respect and empathy simply by sharing and being honest.
>
> 4. Sometimes all the shouting and complaining is not for the right things or skips an EQ check.

Strength comes from inner ability, inner realm. Your emotions, experiences, history, intellect are all inside of you as a destination on its own every hour of the day. Think about the power of that. Think about how your outside self may tell the story to others. Relating to other people is vital to success. People crave inspiration and

innovation. Your job is to go on a tour of what moves and motivates them and then bestow them with your gifts. Innovation is a privilege. It must provide something that surprises and endures.

If you are happy with your "self" and your intelligence and have a higher purpose, you are less likely to be distracted from your goals. However, if emotions overtake you and you do not practice self-awareness and self-regulation, are not motivated or lack empathy, this disjointed state acts to create chaos and can unravel the achievements that your IQ manifests. Don't accept this chaos as normal. Besides, as Maya Angelou said, "If you are always trying to be normal, you will never know how amazing you can be."

Emotional intelligence is a superstar of numerous and varied definitions, which depends on the type of lens (psychological, business interaction, wellness). Thus, the importance of it and its multifarious nature. For everyday innovators, the TalentSmartEQ definition fits: "Emotions are present in everything you think, do, and say each day on the job, in your career, and throughout your life. Emotional intelligence (EQ) is how you handle yourself and others. Your EQ taps into a fundamental element of human behavior that is distinct from your intellect and personality. It affects how you manage your behavior, navigate social complexities, and make personal decisions that achieve positive results. People who develop their emotional intelligence communicate more effectively,

handle stress and conflict productively, are better team players, are able to navigate change, and also perform at a higher level."

Inspiring Others

Research published in the *American Journal of Pharmaceutical Education* has proven that a strong propensity in emotional intelligence increases one's ability to make sound decisions, build and sustain collaborative relationships, deal effectively with stress, and cope to a greater degree with constant change. It enables an individual not only to perform well in the workplace, but also, in accomplishing various other goals and objectives in their life. This is an influential leader.

According to Daniel Goleman, an American psychologist and author of the groundbreaking book, *Emotional Intelligence*, EI has five key elements that, when managed, help leaders attain a higher level of emotional intelligence—and I would add inclusive leadership.

1. *Self-awareness*—Beyond just recognizing your emotions is being aware of the effect of your actions, moods, and emotions on other people.
2. *Self-regulation*—It simply means waiting for the right time and place to express emotions. Those who are skilled in self-regulation tend to be flexible and adapt well to change. They are also good at managing conflict and diffusing

tense or difficult situations. (I would add here that I agree with Oxford Women's Leadership Development Programme emphasizing self-acceptance, self-management, and self-development to fully realize your authentic potential as a female business leader.)

3. *Motivation*—People who are emotionally intelligent are motivated by things beyond external rewards like fame, money, recognition, and acclaim. They have a passion to fulfill their own inner needs and goals. They seek internal rewards, experience the energy from being totally in tune with an activity and pursue peak experiences.

4. *Empathy*—Having the ability to understand how others are feeling is crucial to emotional intelligence and involves your responses to people based on this information.

5. *Social skills*—Being able to interact well with others is another important aspect of emotional intelligence. True emotional understanding involves more than just consideration of your own emotions and those of others. Important social skills include active listening, verbal communication skills, nonverbal communication skills, leadership, and persuasiveness.

What I love most about Daniel Goleman's philosophy: "The best news is that 'emotional literacy' is not fixed early in life. Every parent, every teacher, every business leader, and everyone interested in a more civil society, has a stake in this compelling vision of human possibility." Since I'm never satisfied with the status quo, let's go a step further here with what could be construed as "disruptive EI"—amplifying all these fundamental traits of EI to move mountains for or alongside others. Think influence here. The influence you have over others' feelings and actions. It's like lighting a candle for someone. Innovation is not just comprised of a product or service. It is the power you wield to care, to help, to strike lightning that lights up other people.

4
Continuously Learn

"LIVE AS IF YOU WERE TO DIE TOMORROW. LEARN AS IF YOU WERE TO LIVE FOREVER."
—*Mahatma Gandhi, political ethicist*

Courageous Inquiry
What kind of knowledge would enhance your skillset or rate of success?

Bold Insight
Learning helps build neuron connections. Dopamine kicks in every time the brain is stimulated by learning.

> **Inclusive Practice**
>
> 1. Tools like MindTools and modern course offerings like Masterclass are readily available for quick hits of knowledge or longer-term learning. Wow, we are so fortunate that innovators created these mechanisms for all our brains to access.
>
> 2. Learn something for fun—like no one is watching. It's never "mindless".

I hardly know any entrepreneur or CEO of a major corporation who hasn't used the term, *pivot*, after navigating business through the first pandemic, COVID-19, of our lifetime.

Former editor of *VOGUE*, founder of digital PR firm Lippe Taylor, and self-proclaimed inclusive leader Maureen Lippe, writes in her 2023 book, *Radical Reinvention* (which the making of was a pivot, too, according to her): "Progressive leaders now must treat employees as stakeholders and build relationships with team members based on acknowledging and fulfilling their need for adequate compensation and benefits, autonomy, flexibility, development, and wellbeing in both the workplace and in their personal lives, resulting in increased commitment, productivity, and retention. Authenticity and even vulnerability goes a long way. Avoidance might feel good

in the moment, but it is without courage. Courage is being familiar with failure, disappointment and even heartbreak. Inspiration and imagination are imperative. The softer side of leadership is deeply valued today with more empathetic, compassionate, transparent attributes, but always with strict accountability, so everyone knows where they stand and what's expected of them. Being optimistic with creativity and imagination is a plus. And humor goes a long way, too."

What makes you qualified to pivot? Keeping your brain fed with new knowledge. Always be learning! Our brains are the gateway to personal fulfillment and generational change. When we feed our neurological senses, they light up like electrical currents. Our power intensifies. This power that we all possess starts when we are children. Our imagination and our belief in what we are imagining is untainted. We believe in the impossible.

Two-year-old kids have twice as many synapses as adults. Because these connections between brain cells are where learning occurs, twice as many synapses enable the brain to learn faster than at any other time of life. Therefore, children's experiences in this phase have lasting effects on their development.

This first critical period of brain development begins around age two and concludes around age seven. It provides a prime opportunity to lay the foundation for

a holistic education for children. Four ways to maximize this critical period include encouraging a love of learning, focusing on breadth instead of depth, paying attention to emotional intelligence, especially given the negative impact of social media, and the new way our children are being conditioned to interact, and not treating young children's education as merely a precursor to "real" learning.

Education can transform your reality and that is why I agree to be featured in online courses and lecture for Oxford Saïd Business School. Too many people are stuck in a kind of blurred reality that increasingly diminishes their life, their ability to thrive. One of the cool things about education is that it is your armor. People talk about transformers and superheroes with body armor they would kill for, but we spend very little time speaking about intellectual and emotional armor. Learn something for the purity of the substance and not only to get a job. Your mind is a muscle. Use it.

Education is the gateway to you as a person. You create your universe, the pathways of your own estate in a much healthier way. N*ever* stop learning.

Fighting to Learn

British chemist and X-ray crystallographer Rosalind Franklin battled to get an education, and then battled to gain recognition for her visionary work. The story goes, as

told by *Tech Radar* in "10 great innovators—and what made them great", she was born in London in 1920, and knew her calling was to be a scientist from an early age, but her father objected to women going to college and refused to pay her tuition. Her mother and aunt would convince him to change his mind, with Franklin honoring their support by graduating with a doctorate in physical chemistry from Cambridge University, in 1951. She would go on to play an essential role in producing an x-ray photograph and research that helped show the structure of DNA, the molecule holding the genetic code of all life.

Several male colleagues undermined her every step of the way and when she died of ovarian cancer at the age of just thirty-seven, they were awarded the 1962 Nobel Prize in Physiology or Medicine for the discovery.

Others were credited for this woman's tireless efforts. I like to think that Franklin inspired her male counterparts to look beyond the entitlement of their sex and even if only secretly, admit that they stood on her shoulders. For our benefit, Franklin's fight to obtain her education in the first place will be imprinted forever in modern medicine. You never know how what you learn will be imprinted forever, too.

5
Be a Master Builder

"Trust yourself. Create the kind of self that you will be happy to live with all your life. Make the most of yourself by fanning the tiny, inner sparks of possibility into flames of achievement."

—*Golda Meir, former prime minister of Israel*

> **Courageous Inquiry**
>
> What could you contemplate, design, and execute from scratch? I know the idea is there—don't lose it!

Bold Insight

Acknowledge that barriers exist between you and completion of your build or between your build and your audience. These barriers can erect themselves at any stage, but your job is to stare them down and keep making progress, knowing it will benefit others. If these barriers are *skills*, you can learn them. If this barrier is *time*, you can alter that clock to manufacture more even just a little every day. What we value we prioritize. If this barrier is *money*, don't ever let that stop you from building. There are plenty of steps that can be taken toward an innovation so that when the money presents itself, you will be ready to spend it, hit that deadline for a grant, or present your build in the best light for an investor.

Inclusive Practice

1. Nurture the master builder in yourself, thinking continuously of the innovation you can bring to yourself and especially others.

2. Create your own leadership style that is authentic. Don't shy away from features like firmness, determination, strength, conviction, persuasion, seduction, and most importantly, being accessible.

3. Celebrate successes. Applaud someone else's success always. The world is large enough for you to rejoice in other's success, which means live with a sense of abundance and not scarcity. Success is not a zero-sum game.

4. Invest in your learning to move the knowledge and skillset needle.

In October of 2020, when the coronavirus pandemic was raging, I was interviewed for the Development Bank of Kazakhstan (DBK) about women's empowerment in leadership positions. The president of Kazakhstan, Kassym-Jomart Tokayev, had proposed increasing the participation of women in leadership to 30%. He stated, "It is necessary to promote the idea regarding the empowerment of women as key to economic prosperity and help realize the full potential of our society."

As I noted in the interview, we at DBK have been ahead of the curve in promoting diversity and inclusivity. Since joining the board of directors as an independent board member in 2015, the role of women within the Development Bank has improved. At every opportunity, I advocated for women to be seen as a viable candidate for promotion and I advocated for all employees to be given the proper training to aspire to ascend the corporate ladder and beyond. As of May of 2023, the share of women employed

at DBK was 57,6%. The share of women in leadership positions was at 50%. I was the spark and the internal champion for this type of result, but without employing EQ with IQ, I would not have been successful in creating management buy-in and in garnering internal support. Now it is a team effort and today, DBK can rightfully be considered a benchmark for the gender equality of its employees.

Inclusivity needs to go beyond gender. COVID-19 allowed for all to reassess working from home. With the understanding that people can be productive at any desk, we reinstated our commitment to welcome qualified people with physical disability. And we mean it and put it into motion with action.

Disability rights attorney Haben Girma travels the world to teach about the importance of inclusion, especially on the part of employers. She recalled applying for countless jobs during college and being called in for an interview only for the employer to write her off as soon as she met them as a deaf-blind woman. Nevertheless, she graduated from Harvard Law School and made it her mission to advocate for equal opportunities for people with disabilities. In 2015, the Obama Administration invited her to the White House to meet the U.S. President and give a speech introducing the ceremony to celebrate the twenty-fifth anniversary of the American Disabilities Act.

Before the meeting with President Obama, Girma asked his advisor, Valerie Jarrett, if he would type on a machine himself to speak to her, or if he would ask someone else to do so.

"A lot of people are uncomfortable with something that's different... they come up with all kinds of excuses that basically say 'this is weird; I don't want to get involved,'" Girma explained. But Obama wasn't. "He graciously switched from speaking to typing so that I could access his words. And we had an awesome conversation."

Fear of Diversity Destroys Us

My personal inspiration for advocating DEI is my sister, who is twelve years younger. She is handicapped with spinal bifida and hydrocephalus and other complications. She goes to work every day. Doctors have said, "She's never gonna walk, she's never gonna talk," and surpassing all expectations, Monica graduated university with a Political Science degree, and works for Westchester County. Working hard, receiving a paycheck, paying taxes, being a productive member of society and role model in her own right motivates her. She wants to contribute and not be seen as a burden. What gave her the strength? Us, her family, did not allow her to sink into victimhood. We had a collective determination for Monica that she is fulfilling and is having a fulfilling life. Already her sister, I took on the role of being her life coach, pushing her

further and further. Sure, Monica has everyday struggles, but when she falls, she gets up. "There is no reason or excuse not to be the person I am," she says. Every day, she takes steps to be her own master builder—redefining her future and people's perception. Monica disrupted herself.

Promoting diversity, equity, and inclusion in your interactions can be a significant feature of your personal brand. If you lead a company or organization, pronounced DEI efforts are imperative for retention. Represent what the world looks like. DEI helps everyone feel psychological safety, which impresses upon performance.

As an individual, expose parts of your personal story so others can relate. Storytelling doesn't have to be a faucet pouring out all your life chapters—it can be a sprinkle when connection calls.

Since diversity of thought fuels innovation, engage a variety of "others". Since inclusion can stamp out burnout, be sure you are not isolating for long periods of time in your innovation efforts.

Why do we treat human beings as if they are different from us? When we speak of otherness and then make a decision based on reinforcing the construct, it's nonsensical. There is no "sameness" in our world. There is only diversity and difference.As much as I love inquiry and debate, I would like to wake up to the day when the subject of

diversity and inclusion (D & I) is not something to debate or design lofty programs around.

Circling back to that interview for DBK, investing in people starts with people investing in themselves. One of my statements wraps up my stance on a lot of things as an inclusive innovator: "Opportunity is a state of mind and choice, regardless of the context. Many people, including me, have attended online courses, are still looking to develop skills, to challenge ourselves, and some have not. I would like to add regarding management, that it's extremely important for companies, institutions, and managers to create a psychologically safe environment. You shouldn't see your employees only as subordinates, but as people first and positive contributors. At the same time, you shouldn't be psychotherapists for them, and hierarchy should be respected but not stifling. Psychological safety is about creating an environment in which people can learn, generate ideas, where people feel comfortable offering ideas. Even if you have the lowest position, but you have a brilliant idea, a manager needs to be accessible to hear that idea otherwise the manager is failing its organization and failing as a manager. A brilliant idea can come from anywhere and from anyone. I would like to note that the world is not standing still. Stereotypes and attitudes about gender, ability and otherness is being challenged. The pandemic and its consequences only accelerated this process. I can confidently say that a woman or man or a

physically disabled person with laptop can help lead your company to success no less than a man in a tie sitting on a leather chair."

Women and all at my tech company don't need to get a folding chair. They have a chair at the table. Similarly, at DBK, all are invited to partake in understanding and are sought out as valuable. The environment is inclusive. The space is safe. The question then is, are you going to continue at the table or backpedal to the corner?

When times are tough, for some, it is easier or even natural to break—break something, break down, *break*. But what if, in those times you may be on the brink of breaking, you decided to build something? When you have tools, such as the right mindset, it feels satisfying to break barriers instead of permitting yourself to be broken.

Build or Break

Only 16.5 percent of inventors named in international patent applications in 2020 were women, preliminary World Intellectual Property Organization (WIPO) statistics reveal. Over the past decade, this share has increased by 3.8 percentage points: While numbers are going in the right direction, progress is slow. WIPO estimates that, at the current pace, gender parity amongst patent system-listed inventors will only be reached in 2058.

Global and regional research commissioned by WIPO contributes to cast light on the multifaceted barriers that may exclude women from using IP services. Barriers include the lack of access to networks, mentors, sponsor, and role models; scarcity of financial resources; negative bias and the burden of care responsibilities. Needless to say, this limits their materials from which to build on! I hold many patents so I'm well-aware of the deep resources these took to be granted intellectual property ownership and the highest level of protections.

I've talked about my concept of "master builder" in a TED Talk and other venues. I refer to the *collective me*. But it's never solely about me as the individual. The collective me innately considers others, particularly our youth. In English, if you turn upside down the "me" it becomes "we", which symbolizes the importance of collective contribution, because no change will be brought in isolation. *Me* and *we* are interchangeable. When you support tenacity, grit, and gumption, and believe in other women's success, it matters.

We must simultaneously empower girls and educate boys. Consider a universal example: sports. Teamwork is an important life skill to instill early, along with time management and commitment. Let's start with soccer, which my daughter was playing as I was busy restructuring an international banking system on the other side of the

globe! Flying home in time to see her games, I noticed fathers were on the phone when girls ran onto the field. Disengaged. I noticed there was no thought of preparing the girls with skills or strategy. When I asked why, the response was, "We are just happy they are here." What a low bar! Shocked and disappointed, I took over. Create the world you want, right?

I started coaching my daughter's team. One season turned into six seasons. I had girls that flinched at the balls coming at them. This is soccer. You can't avoid balls. Do you know what I did? I challenged their fear, throwing the balls at them for them to learn how to navigate the ball and its impact. I didn't take this course of action to hurt them. I did it to empower them to overcome the fear of getting hit because fear can deter success. Sometimes fear is more painful than the impact. Those same fathers who were disengaged started cheering them on. They were present. They were excited by the girls winning, developing skills, and brimming with confidence. These girls were not initially bad at the sport. They were deliberately short changed. Parents, especially male coaches, would state that they were happy the girls were even on the field. They were sent out with no strategy and little skill training. There was nothing intrinsic in the girls that made them play badly. The environment was holding them back. Now girls were wearing their scrapes and bruises as "war scars"—a badge of honor and not something to hide.

How we nourish our girls is imperative because confidence is a trait to be planted early. From redefining a physically disabled person's belief in themselves to providing the same care in instruction and coaching. The soccer girls learned to train under pressure and perform regardless of their feelings. They learned to show up and buck up. They learned to lose and win equally and gracefully. It was transformational to not only the girls, but also, their families. Fathers now walked off the field, shoulder to shoulder, exuding pride and spitting out statistics. Brothers looked on with respect and younger sisters started picking up the ball. Take ownership of yourself. In every team, there is a captain; be it. Be that leader. Break barriers.

When you are lonely and struggling or feel that you aren't supported, perhaps think about the giants before you who started to carve the path. Be grateful and pay it forward. When you open that door, you flip the me into we from your courageous act of stepping in. Your contribution emits ripple effects. There is enough room everywhere for people to do well.

Insight: The Power of No

On the path of being a master builder, take "no" as inspiration, something that inspires you to go forth. This is a topic I'm known for and worth touching on further. Be inspired by

no not because you must prove something to others. This is solely about you.

I spent my entire career being a master builder and a mentor starting in investment banking in the nineties and then creating a tech company and becoming a bonfire software and design inventor with patents globally. There were no ready-made blueprints beautifully designed by other women. No real network to power you along. I majored in political science. I was supposed to fail in banking. I thrived. I had no coding skills to run a tech company. Yet, I became a patented software and design inventor. I worked on being my own "master builder" comprised of proactively learning, developing skills, knowing what I didn't know and completing the trek to find that knowledge and of course, challenging the status quo along the way. If you are not going to be your own master builder, there is no prince or princess charming or magical wand that is going to be your life architect. If you don't think you can be a builder, who wants to build around you? If you do not invest in you, why should anyone?

Acknowledge that barriers exist. Take the tiny steps required to change them. It won't ever be a gigantic leap that lands you into stardom.

When you are lonely and struggling or feel that you aren't supported, perhaps think about the giants before

you who started to carve the path. Be grateful and pay it forward. When you open that door, you flip the me into we from your courageous act of stepping in. Your contribution emits ripple effects. There is enough room everywhere for people to do well.

6

Thrive on Curiosity and Courage

"Critical thinking and curiosity are the key to creativity."

—*Amala Akkineni, actress*

> ### Courageous Inquiry
> What topic do you find fascinating, but you've put off learning about?

> ### Bold Insight
> Psychologists, anthropologists, economists, historians, and philosophers have all studied curiosity for mental health, physical health, buying trends, societal progress, and the direct correlation to innovation.

> **Inclusive Practice**
>
> 1. When you are on the brink of judging someone or a situation (i.e. stating an opinion), ask the journalist's five questions: Who? What? When? Why? How? This immediately diffuses the judge inside and sparks the observer, witness, and innovator.
>
> 2. Exist to solve problems instead of being right.
>
> 3. Contemplate what the world urgently needs now and explore the topic. A conversation can change the course of history.

I was blessed to have been born into a family that values the love of learning. They understood that there is of course, a practical need for education to lead to a profession, but as importantly, they fostered knowledge as part of personal fulfillment. In my family, we were not only required to be curious—we had to talk about what we were learning or what we wanted to know more about. In the search for knowledge, we learned to respect our elders' experience and wisdom and gain wisdom from diverse sources. We had to debate and listen to opposing views regardless of how it made you feel. We needed to arm ourselves not with sound bites or other people's talking points but with independent knowledge born from our own curiosity. To be able to listen and therefore, effectively

debate, we were taught to humble ourselves. Perhaps we should teach humility a little more. Humility to me is not thinking less of yourself but thinking of yourself less. We welcomed the challenge to find the answer or solution. With our 'to do list' it was off to the library, newspaper, or backyard we went. We had to *do something* about our hunger for answers. We had to show curiosity and have the courage to follow up in some way. I was raised to believe that the more education and intelligence (not necessarily institutional only), coupled with EQ, that you have, the better armed you are. The stronger you are. You are covered. You're more at peace with yourself. Your mind is interesting to you. Stretch to immerse yourself in types of environments that calibrate your mind and challenge your status quo. For this very reason I miss being at Oxford more regularly. I miss the debates and discussions, and walking on those amazing cobblestone streets where greater people walked. You can feel the collective energy and intelligence that has led to countless innovations and brightened up the globe.

In a piece on curiosity, *Psychology Today* cited a to-do list from Leonardo da Vinci's notebooks:

- Calculate the measurement of Milan and its suburbs.
- Find a book that treats of Milan its churches, which is to be had at the stationer's on the way to Cordusio.

- Discover the measurement of the Corte Vecchio [courtyard of the duke's palace].
- Get the Master of Arithmetic to show you how to square a triangle.
- Ask Bendetto Portinari [a Florentine merchant] by what means they go on ice at Flanders?
- Draw Milan.
- Ask Maestro Antonio how mortars are positioned on bastions by day or night.
- Examine the crossbow of Maestro Gianetto.
- Find a Master of Hydraulics and get him to tell you how to repair a lock, canal and mill, in the Lombard manner.
- Ask about the measurement of the sun, promised me by Maestro Giovanni Francese.

How rich is that? These are actionable steps concerning the tools, resources, and knowledge toward an innovation. Thinking about your big idea, can you duplicate it with the same stroke of deliberation and detail?

Dr. Carol Dweck coined the terms, *fixed mindset,* and *growth mindset,* to describe the underlying beliefs people possess about learning and intelligence. Dweck found in her research that one of the most basic beliefs we carry about ourselves has to do with how we view and inhabit what we consider to be our personality. A "fixed mindset" assumes that our character, intelligence, and

creative ability are static givens, which we can't change in any meaningful way, and success is the affirmation of that inherent intelligence, an assessment of how those givens measure up against an equally fixed standard; striving for success and avoiding failure at all costs become a way of maintaining the sense of being smart or skilled.

A "growth mindset", on the other hand, thrives on challenge and sees failure not as evidence of unintelligence but as a heartening springboard for growth and for stretching our existing abilities. Out of these two mindsets, which we manifest from a very early age, springs a great deal of our behavior, our relationship with success and failure in both professional and personal contexts, and ultimately, our capacity for happiness.

This is a measure of relief to know that respected figures like Dr. Dweck examine the mind in this way and teach us how to easily examine and choose how we want to function in this world.

Dweck found that at the heart of what makes growth mindset a winning proposition is that it creates a passion for learning rather than a hunger for approval. Adopting this mindset will not only decrease your worries of being discouraged by failure, but Dweck's research tells us you are unlikely to see yourself as failing in hard situations; you will see yourself as learning. Human qualities such as

creativity and intelligence, and even love and connection, can be cultivated through effort and intentional practice.

Cultivation of a growth mindset will help you cultivate courage because it *rewards* not knowing it all. "I don't know" turns a lack of knowledge into an opportunity for personal improvement. You *currently* lack the knowledge or skills but you're willing to work to acquire them.

I turned my growth mindset into hyper focus when I founded Blingby, a B2B2C-specific content-to-commerce and content-to-knowledge digital interactive technology. I was told by everyone in tech, "No one knows you in marketing and advertising." That is true. No one did. I was the founder and CEO of a tech company without being a developer or having come from the tech world. The challenge of starting the operation could be summed up as: How do you take a good idea, a really good idea, make it real, make it marketable and raise money? That is a significant challenge especially in the tech sector. A lot of people think you have a great idea for tech and *poof*, someone will invest. That's just not true. Taking that idea from concept to prototype and something real and tangible is very challenging. And making sure you have the right people around you is a huge challenge. Finding the right people to surround yourself with and help you go from concept to product is a real challenge. It requires not only a skill set but an alignment of the mind-set. *Psst!*

Condé Nast, HBO, the U.S. Air Force, and others have used my technology.

Do not put yourself in a panic box. You do not need to know everything. You need to know how to activate that idea flickering in your mind and assemble the right team to execute under your leadership. You need curiosity and courage. Create a cognitive revolution even if only within yourself.

In *Sapiens*, an exhaustive history of humankind, author Yuval Noah Harari describes the Cognitive Revolution that brought new ways of thinking and communicating between 70,000 and 30,000 years ago. We only hear of the Industrial Revolution, but the Cognitive Revolution "witnessed the invention of boats, oil lamps, bows and arrows and needles (essential for sewing warm clothing). The first objects that can reliably be called art [such as the Stadel lion-man, an ivory figurine from the Stadel Cave in Germany] date from this era, as does the first clear evidence for religion, commerce, and social stratification. Most researchers believe that these unprecedented accomplishments were the product of a revolution in Sapiens' cognitive abilities. They maintain that the people who drove the Neanderthals to extinction, settled Australia, and carved the Stadel lion-man were as intelligent, creative and sensitive as we are. If we were to come across the artists of the Stadel Cave, we could learn their language

and they ours. We'd be able to explain to them everything we know—from the adventures of 'Alice in Wonderland' to the paradoxes of quantum physics—and they could teach us how their people view the world."

This is a reminder that we, as a species, never needed automation, technology, or social media to think, feel, interact, and create. Our ancestors proved tens of thousands of years earlier, we always had superpowers waiting to be awakened.

7
Close Windows, Knock Down Doors

"If opportunity doesn't knock, build a door."
—*Milton Berle, comedian*

> **Courageous Inquiry**
> What's stopping you from being courageous?

> **Bold Insight**
>
> Courageous acts are exhilarating, even addictive. They sometimes start with that uneasy feeling in the pit of your gut. Then when you make the first move, your thumping heart tends to ease in sync with the rest of you. Then you have flow. At minimum, you just deposited more courage into your system. Or you have a best-case scenario that is *it all*. Most courageous acts involve other people, Remember, we're all people!

> **Inclusive Practice**
>
> 1. When a challenge feels gargantuan, break it down to pieces you can control and master. Soon, you will have the whole puzzle framed.
>
> 2. Danger, fear, and degree of difficulty do not necessarily go away when you act. You must persevere and withstand all the above to build courage.
>
> 3. You must try new things to grow. Growth comes from experience.

Inclusive innovators possess curiosity and courage. They seek comprehension, not quick answers by way of memorization and getting by. They raise the bar. They do

not have the "blue ribbon" mentality. *Psst.* I don't think you should get a blue ribbon for showing up or we, as parents, need to be forced to listen to a bad cellist and applaud them that they tried on stage. No, you should have practiced! Have we lost the ability to cope? How can you develop coping mechanisms if you never fail? If you believe that any effort is equal to real effort? They don't hear, "Go practice. Then earn your place on the team after you practice over the summer." Instead, they hear, "Ah, you tried!"

It's so rewarding to go the length. You function not only with a sense of achievement; you feel a sense of richness. We welcome a culture of excuses and a lack of resilience. If you want to be average, that is fine but accept the outcome of your life being average. Don't drag people down to make you feel better. Don't take or covet your neighbor's things. Don't hate others for what they have or achieved.

When you have values that are concrete, nonnegotiable, they illuminate your purpose. It's like adjusting the lens of a camera and settling on the sharpest focus. All else—questions, priorities, tasks that don't tie to your purpose in some way—becomes minimized.

Donna Wilson, who retired as head of diversity, equity & inclusion multicultural marketing at Johnson & Johnson, went the extra miles oftentimes walking them alone, to adapt, present and represent at various levels

of leadership. Her voice became iconic and influential for new product innovations that saved and changed communities, raised and empowered teams, reached across aisles, created an inclusive culture, and gained a powerful group of stakeholders along the way. Her purpose to innovate in white space, coupled with her personal brand, was empowering. At a leading payment card company, for example, Donna oversaw strategic direction of sixteen Global Employee Networks, with sixty-two chapters, spearheaded strategic direction of seven Global Diversity Councils chaired by the vice chairs, and advanced global market segmentation strategy, resulting in two new business products.

At another company, Donna spearheaded diversity management initiatives for its businesses encompassing 250+ brands on a global basis, ultimately designing and executing a $600 million strategy to address market changes. A *master builder* who closes windows and opens doors again and again!

She advises, "In order to be successful at innovation, you must have an inclusive lens to be sure everyone is sitting in the room when you're designing. Part of designing is the organic dialogue that will lead to the material for the product or service. Your innovation will unveil itself though the brainstorming in that room. Include as many people as you possibly can in that sampling and ask, 'Why

isn't this working?' That is where your innovation will be birthed because those are nuggets you can tease out and innovate from. Never live in a myopic space. Don't hope an idea transforms into something new and exciting. Own it and commit to making it happen. The thrill of innovation *is* inclusion—ultimately seeing the invention or intervention, as Marcia says, together."

I've sat in these rooms Donna describes. I've led many electrifying brainstorms. I wouldn't be here writing of the lessons from those rooms without diverse heads facing me and one another on so many meaningful occasions.

When we are involved in digesting knowledge that supports and relates directly to fulfillment of our core values, we are filled with enthusiasm, energy, and motivation. When these lessons serve our desire to make important contributions to the world, our self-esteem is increased, our confidence is improved, and we perform at our highest levels of productivity, creativity, and effectiveness. Our desire and ability to learn is inherently increased when the lessons themselves come to us closely aligned with our core values.

When I started at investment banking, at a pure disadvantage to the undergraduate business majors, I knew I needed to make money, and the industry sought individuals who excelled at liberal arts. I took the risk. I thought it would be a fun challenge, but I was at a disadvantage. I did

not know the basics like EBITDA (earnings before interest, taxes, depreciation, and amortization), a key financial metric. I never spent time measuring myself negatively against someone else. Although a highly competitive environment, I focused on challenging myself. The notion of "competition" against people didn't fit anywhere, so I didn't compete against others. I challenged myself to do better, and in the process, took up space. I ended up going from not knowing EBITDA to creating a better suited metric for emerging market issuers, the External Credit Ratio. To this day, it's still in use. And I went on to create an international benchmark. Do not apologize for taking up room. Just because I take up room doesn't mean I have to take up your room.

8
Never Apologize, Always Enlighten

"While we teach, we learn."

—*Seneca, writer*

> **Courageous Inquiry**
>
> Did you ever apologize for the wrong reasons? Before you make a decision that impacts others, are you armed with an intelligent explanation?

Bold Insight

Knowing when to apologize is as important as knowing how to apologize. Allow me to enlighten! Take responsibility when you have done something wrong. Make amends when you have legitimately hurt someone—not to make others comfortable with your intelligence, candor, or innovation. I'll just say it: Too many women fall into the trap of saying "sorry" as often as "hello" and "goodbye". If you are among them, explore why. Apologies should come from honest remorse, not to fill dead air in between words, or dilute your power or position or make a hater feel better.

Inclusive Practice

1. Think about the recipient of your words and actions. Analyze the situation. Is an apology or explanation warranted? Will it add value? Will it have the intended impact?

2. Information exchange opens new lines of communication. If you are unsure if you're communicating effectively, it's likely that you're not. Confidence and preparation breed effective communication.

> 3. If you take a little more time to enlighten, push through that last thread, your outcome will be all the better. Your message may be remembered and shared.

When you apologize, you might be seen as being a reasonable person, or, if unsubstantiated—weak. This aperture can undermine your power or meaning. In fact, sometimes being a leader of innovation and inclusion will require you to be a little unreasonable. Don't be reckless but be a risk taker. Be comfortable in being uncomfortable. Ludovic Phalippou, a fellow at Queen's College, Oxford, has been distinguished as one of the premier professors in economics worldwide and has raked in numerous accolades. For one of his private equity classes, Ludovic brought me in as a guest critic. I was honored to be asked to review the work of his private equity class and present my findings and critique to the class. The purpose is in essence, to guide and correct and negotiate understanding. *Negotiation.* That word again.

The exercise in class that day revolved around acquiring an underwear company—and not just any type. This was for luxe British retailer lingerie company, and the students had to create a deck of PowerPoint slides to make their investment case. The CEO was in attendance, so this was no average day of class!

I will share the raw version of this incident because it is relevant to being a master builder on so many levels. I had a stack of material to review. Eighty people in this private equity class, pitching a product for the company to buy, and the CEO told everyone they did a great job. But they did not. An MBA student at Oxford was washing her hands in the bathroom after the presentations had been given. I suppose we both needed a break! The student looked at me and then herself in the mirror and looked down. I got close, washing my hands, and winked and smiled an acknowledgement. She asked me if I worked for the lingerie company. Given the question and her being a young, Asian woman, I was so curious what her impressions were of the male-dominated presentations, but there was no time to dissect it all. I said, "Hold that thought." We went back into the class and Ludovic introduced me as the guest critic. The girl was first shocked and then flashed an infectious smile.

I wasted no time with conventional greetings or coddling the students. I started showing the covers of the pitches that had been turned in. A lot of the pitches featured images of women of different races bending down with their butts out. I went through every presentation—those with women on all fours, including one that could have been construed as not only sexist but also, racist. I showed one pitch book and said, "This one is obviously from someone who is emotionally arrested,

like a twelve-year-old boy looking at *Hustler*." I heard a cacophony of chuckles, gasps, ad lib. One older gentleman quipped, "Well, boys will be boys!"

"Really? I thought this was a graduate class and not high school. Remember you are asking for me to invest in your project or opportunity. You are asking me to choose you." I reminded the 'boys' that I am in the driver's seat in this simulation because they wanted me to invest in their project.

I walked up to a student and asked, "Let's put aside that you are pitching to a woman. What if you are pitching a devout Muslim, Mormon or Catholic, a man? Or simply, a mature man? How would that come across?" Why would I go ahead with you showing such low EQ? At that moment, the "boys, will be boys" quip became, as it should, an infantile comment. People began to look uneasy. Good!

Someone will always need money for a wonderful idea. In fact, millions of brilliant minds will have birthed a product they know is worthwhile to bring to market. Your pitch for these funds matters as much as your breath does! Be smart. Connect with a higher emotional IQ.

My critique resonated. Both men and women students followed out and thanked me for being relevant, sensitive and critical. By the way, I had also talked about the analytical quality of the pitch.

One guy finally huffed, "What did we do *right*?"

I said, with a smile, "Take this class!"

The class let out a collective laughter. Always bring humor. Balance strength with laughter and accessibility.

Ludovic had been holding his breath. He didn't disappear after that class. He acknowledged me in his book on modern private equity.

This is a quintessential example of authenticity. I did not mince words to be liked or need the male gaze to fall with acceptance in that classroom of extremely bright students. They made amateur mistakes for the level of education that we were all riding on together. They needed to be called out. The lack of DEI and EQ could have had substantial professional and financial negative impact. They benefited more from someone who was forthright about the need to practice awareness and display a balance between EQ and IQ.

Ludovic says, "The Marcia experience is a perfect illustration of what is her unique contribution to leadership. She behaves the way she feels, but always with empathy and a smile." Thanks, Ludovic! Stepping out of the mold can require you to be loud and outspoken, which can be mistaken initially as unreasonable in the name of what's right, but ultimately, accepted as the right thing.

Innovators Wear Lingerie, Too

Guest lecturing in that class revolving around a lingerie company, of all things, reminded me of Hedy Lamarr's life. She stands as a shining example of an innovator defying convention. A glamorous Austrian American actress during MGM's 'Golden Age', Lamarr certainly doesn't fit the stereotypical image of what an inventor should look or act like. But every time you connect to Wi-fi or use Bluetooth on your phone you have the Hollywood actress to thank, at least in part.

In addition to starring in films such as "Samson and Delilah" and "Lady of the Tropics" alongside the likes of Clark Gable and Spencer Tracey, Lamarr was also a self-taught inventor—an aspect of her life which she largely kept secret. At the start of World War II, she co-invented an early technique for spread spectrum communications. Designed to allow Allied submarines to guide torpedoes more accurately toward their targets, the principles of the technology are incorporated into today's wireless communications tech.

Her innovative mind was quieted to cater to the movie industry, which demanded only her sex appeal. More people should seek beyond her gorgeous face to know about her extraordinary achievements and how she continues to impact you today beyond the 'silver screens'.

When physicist and chemist Marie Curie made her greatest discovery, she didn't close the door on other women or apologize for brilliance; she made all her research relating to the discovery of radium available to the scientific community, encouraging others to further develop her findings. She opened all the doors and windows, letting the fresh ideas in!

Born in Poland in 1867, Curie's achievements were more incredible given that when she was growing up, girls were forbidden from attending college, forcing her to receive her education at the 'Floating University', a clandestine institution operated in secret from the Russian imperial authorities. After moving to Paris to further her studies at the Sorbonne, which accepted girls, she would go on to become one of the most ground-breaking scientists of all time.

Best known for her work on radioactivity and for discovering the element polonium, she would become the first person to be awarded two Nobel Prizes: one in physics, which she won jointly with her husband,

Pierre, and Henri Becquerel, and another in chemistry.

Curie was also responsible for establishing the theory of radioactivity, but ironically, she died in 1934 from leukemia caused by radiation exposure. In the extensive literature dedicated to her memory, she is credited most

for her "bright and curious mind". I wish I could go back in time to see the doors Marie Curie walked through.

The Roman god, Janus, was the god of doors and doorways, and the god of beginnings, endings, transitions, gates, gateways, and time. Doors are connecting points. They are all entrances, not exits. If you don't walk through or kick it down when it's a little harder to open, you are self-restricting.

Be creative. Challenge yourself to see things differently. So many people are creative and don't realize they are yet. I saw a need for content management in a digital world that could facilitate videos, movies, lectures. I wrote the plan down on a piece of paper and did it, just like the Burden Sharing Restructuring Framework. When someone says, "you can't do this," I say, why? Once you tell me, you're filling me in on how you expect me to fail, and you're giving me a blueprint for success. Thank you.

Never apologize for having done something successfully. Your job as a leader of innovation and inclusion is not to make someone comfortable. In fact, practice shaking them up like you will an entire audience or customer base. If you are a woman, remember you are not a therapist for stakeholders entangled in their own issues. Women are taught not to be confrontational. And if you're not, think about the cost. Call it constructive confrontation if you wish, but do not shy away from setting boundaries and

delivering feedback, whilst being inclusive, which means you create psychological safety, see, and listen to others who trust you. You're also innovative so you're known for solving problems in creative ways. You, too, must claim the space to be bold and assertive when necessary.

9
Accept Failure as Fire

"There is nothing impossible to him who will try."

—*Alexander the Great, king of Macedon*

Courageous Inquiry
What have you learned from past failures?

Bold Insight
Recruiters, personality tests, and performance reviews all ask about failure because they want to test your ability to cope with failure. They expect you to have failed (in the real world, there are no blue ribbons). Everyone does. Emphasize trying something new. Emphasize how you grew from the failure. Emphasize results.

> **Inclusive Practice**
>
> 1. Failure is invaluable when it leads to improvement. Pull up those improvements and experiment.
>
> 2. Document a past failure. Own the failure and contemplate how you will do better in the future.
>
> 3. Reflect on lessons. Describe them vividly. Inject humor. Inject inspiration, even if you are the only one to see this chronicle.

I don't think failure exists unless you didn't learn from it. When I look at the whole picture, I've been successful. I learned. I fixed something. To me, it's an iterative process, it's not an event. In business, in trading, we say, *fail big*. Risk takers are respected, even those that loose significant amount of money. These traders and portfolio managers get hired after losing all that money because someone entrusted them with this amount of money. They went large. They *fail-upward*. Too many people shrink at failure. Why not be proud and create a narrative design around what you did and what happened and how you can better master the next phase? People have failures every day; it's not the point. It's experience. Failure is experience.

Identify Saboteurs

Is pain, loss, anger, disappointment, regret, or self-doubt holding you down? Be comfortable in being uncomfortable. You never see a boxer crying that he or she got hit.

The inner battle is waged every day of your life if you don't identify the saboteur, process the root or the wound, and declare victory over the saboteur. These incessant battles will rob you blind of time, energy, confidence, sleep, health, relationships, and other resources needed for you to progress in your innovation. Resolution, or at least reconciliation, or peace, is critical.

One cure for saboteurs is spirituality. Innovators and entrepreneurs need to talk about faith and spirituality more. I am very practical, but I also harbor a very spiritual side, which adds a huge element to mission and alignment of skills to mission and my overall wisdom. Make time for it. Take a pause to let the world's wheels spin without your participation, even for a moment in time. Most have a hard time letting go, perhaps because of fear. Let it go. The world needs a mentally, spiritually and physically stronger you.

At fifty-four years old, this year, I walked the *Camino de Santiago*, otherwise known as the Way of Saint James "recognised as the most innovative, expansive, inspiring and consolidated pilgrimage and cultural route in the world."[4]

4 https://www.ncbi.nlm.nih.gov/pmc/articles/PMC10150338/

This pilgrimage open to anyone and everyone has existed for over 1,000 years, calling hundreds of thousands of pilgrims every year. It dates back to the 9th century (the time of King Alfonso II of Asturias) when the remains of Saint James the Apostle were first discovered in Northern Spain. Walking hundreds of kilometers, alone, with a backpack and trust, throughout Spain to arrive at the tomb of Saint James left an indelible mark. It challenges your motivation, self-regulation, expands self-awareness, allows for empathy, and calls on your interpersonal and exterior, social skills. Imagine. Waking up and throwing your backpack on for another twenty to twenty-five kilometers, or more, walking for six hours a day, and repeat day after day, unwaveringly to reach a destination that does not entail a bonus or applause, just a commitment. This type of commitment brings balance, and balance is essential for outcome and for the personal flow of happiness within you and what you exude to others—that is huge. It is positive to have faith, which can be the grounding for your mission. I know from firsthand experience it tends to lessen the power of any saboteur. Remember, just like fear, it requires your time and energy for it to hold any significance.

Maureen Lippe, whose agency retains 100+ corporate clients at any given time, such as Botox, Nestlé, Citi, Keurig, Pfizer, sees mistakes as fuel. It doesn't mean there is never the threat of a saboteur, or plain feelings of failure or regret involved. When the emotional state evens out to become more practical again (the key is not to linger in the feelings),

there's a shift of clarity that happens toward progressing upon the experience.

She explains, "Six, seven years ago, it became so apparent to me that if I didn't have the data/analytics that supported the insight that drove the strategy, we weren't going to win any more on creative alone. And then there is the presentation to the client, which is extremely important. I had to reinvent Lippe Taylor to meet this new shift and fast to meet the new demand. In 2015, I lost business because the company was not digital enough, and we didn't have the data. I hired every digital superstar in New York City. They were the smartest people in the room, but they couldn't manage others. They were brilliant at explaining what 'should' be done, but never able to actually do it. Honestly, after cycling through many consultants, I knew our days were numbered if we didn't bring in a transformational leader who was capable of changing the agency and seriously bringing us into the Digital Age. I didn't want my agency to become a dinosaur. I knew I was forward thinking, having started many successful programs for many big companies. I had to figure this out and quickly."

Ultimately, Maureen found that person, a master at analytics and data and digital. They reimagined the company together—and doubled the business during COVID-19. What an inspiration!

I particularly relate to what she has to say about that

era, which directly portrays her as a leader of innovation and inclusion. "As with most trends, COVID-19 was an accelerator. It didn't create new trends for us. It accelerated more digital presence in clients. A crisis can drive people apart or bring them together. In some agencies, the leadership teams disappeared and focused on their individual lives. They were too panicked to be there for others or didn't know what employees expected. Some did the opposite, clamping down and trying to micromanage everything. We did our best to reinforce our values, support our people, and bring them together with the right amount of transparency, communication, and connection. Doing so accelerated our reinvention."

Apple or Ada?

Tell me if the mathematician and writer Ada Lovelace failed. She was born into aristocracy as the daughter of the Romantic poet Lord Byron. She would head down a decidedly different path than her famous father, breaking the conventions expected of noblewomen in the 19th century by studying science. Her unconventional education, coupled with her ability to 'think outside of the box' long before the term was coined, helped to lay the groundwork for the computing revolution that began a century later.

Aged seventeen, she met the inventor Charles Babbage, beginning a lifelong friendship. Babbage was working on a

machine known as the 'analytical engine', now recognized as a very early version of the computer.

Beguiled by the machine, Lovelace began contributing to the project. Dubbed 'the enchantress of numbers' by Babbage, she wrote reams of documentation about the pioneering invention, with her observations including the idea that such a machine could manipulate symbols in accordance with rules, and that numbers could represent entities other than quantity—a breakthrough that marked the fundamental transition from calculation to computation. Although she died young, Lovelace left an invaluable legacy, with her observations informing mathematician and computer scientist Alan Turing's work on the first modern devices.

10
Master the Mentor's Magic

"Our prime purpose in this life is to help others. And if you can't help them, at least don't hurt them."

—*Dalai Lama, spiritual leader*

Courageous Inquiry

Do you want to shape tomorrow's leaders? Are you going to open doors and keep them open as you pass through? Are you willing to reach back and bring someone worthy along—no strings attached?

Bold Insight

The highest sense of recognition you may feel is that you give yourself. The sense of fulfillment and personal growth can be astounding when a mentor looks back at their relationship with their mentee or when you see a person take an additional step toward fulfillment or culture change and with it, you impart an unstoppable force.

Inclusive Practice

1. Are you accessible in your demeanor and state of mind? Can you take extra time to focus on others' needs? Do you engineer a psychologically safe environment for others to be productive?

2. Are you willing to constantly evolve in your communication skills? As a mentor, you work on your verbal and written communication skills by working with your mentee and having conversations. This is great practice for tough negotiation.

3. When you are a mentor, you are a leader and a role model. This dynamic relationship will surely help to improve your leadership skills over time.

4. Build a mentoring relationship—friends or family members can be mentees if you aren't currently plugged into a professional or academic inner circle.

5. Listen attentively to those outside your network. Be bold on calling out faults and needed redirection of yourself and others. We live in a world of 'my truth', which in its extreme, is muddling analytical thought and positive debate and perhaps even breaking down relationships rather than providing an environment of mutual growth.

6. Motivating and encouraging others has a mirror effect. You may need a little of this, too. Mentees are good sounding boards for your big ideas and are not (usually) direct competition or naysayers.

In reality, we are all mentors and mentees, even role models. The exchange of support does not need to be an official appointment or certain condition. Like in Ludovic's ingenious class on marketing and selling to a lingerie company, a simple smile of encourage and a moment of "hold that thought" can make an impact, elevate, redirect, and make one ponder. To be that person, that role model, for a moment in time for others, takes only a state of mind

and a contextual awareness that *you are that person* who wants to inspire people and pass your blessings forward.

We are being watched all the time and emulated or analyzed, regardless of our willingness or direct participation. So, be aware and conscious, and heal the world by example. This is magic!

For the person on the receiving end of the mentor's magic, reflect on how is it to work for someone who has accomplished so much yet is accessible and requires a lot from you inside the cycle of passing it on? I encourage you to give it your all based on who *you* are and the quality of life you desire. If you want that seat at the table, ask truthfully if you are ready. People think they should have a place at the table, but if you've shied away from challenge and never really known failure or struggle, not to mention can't accept authority of knowledge and hierarchy of wisdom, the chair breaks and crashes. Trust me, you do not want that kind of scene.

Be humble and realize that your mentor and team are investing in you. You are taking up time and money and are a big red dot until you can add and substantiate value. People are financing you. I'm mentoring happily, as are others, but the mentee needs to be committed and grateful. When you are grateful, you internalize it and pass it on. When you give, keep it beautiful and without strings.

The intention always is to do no harm and pass your blessings on.

Operate on a higher plane. Success, to me, is what Ralph Emerson Waldo said: "Someone breathing easier for the mere fact that you existed." Sometimes we only look at shiny objects as representatives of fulfillment and success. But a lot of emptiness that people feel is related to this mindset of "me against you" and acquiring shiny objects. We need self-accomplishment and gratitude.

Know mentoring is not a one-way street, as everyone learns from the give and take. Mentorship is energy that is exchanged. Humor me. Allow me to be your mentor in this moment. This book carries decades (centuries, if you consider the influence of my ancestors) of experience and wisdom. If I provoked you or caused you to learn something new, we shared mentor's magic. If you related to some of my experiences or saw the relevance in another book or source I cited, we shared mentor's magic.

In a way, the strategies in this book were indeed, based on mentoring. It doesn't need to be a formal mentorship agreement to be a powerful relationship. So I end by asking, if you were called tonight, would you answer the call for innovation?

References

Interviews by Author

Monica Favale. Phone interview. April 19, 2021.

Ariell Ahearn Ligham. Zoom interview. January 25, 2021.

Joel Motley. Zoom interview. March 4, 2021.

Ludovic Phalippou. Zoom interview. January 20, 2021.

Publications

Ansar, Atif, and Ariell Ahearn. "Banking Sector Restructuring Program in Kazakhstan—BTA Bank JSC." Said Business School. May 25, 2015. (Limited audience.)

Balle, Louise. "Information on Small Business Startups." *Houston Chronicle.*

https://smallbusiness.chron.com/information-small-business-startups-2491.html

Blingby.

https://blingby.com

Brevan Howard.

https://www.brevanhoward.com

Brouk, Tricia. *Influential Voice*. Franklin, Tennessee: Post Hill Press, April 27, 2021.

Club de Paris. "Conference on Sustainable Financing of Emerging and Developing Countries." June 16, 2010. https://clubdeparis.org/en/communications/event/conference-on-sustainable-financing-of-emerging-and-developing-countries-16-06

Development Bank of Kazakhstan. "Women's Empowerment: The Role of Kazakh Woman in Corporate World." October 28, 2020. https://kdb.kz/en/pc/news/news/8612/

Favale, Marcia. "Grasp the Chance." *The Business Year*. Kazakhstan 2012 edition. https://www.thebusinessyear.com/kazakhstan-2012/grasp-the-chance/guest-speaker

Gibbons, Serenity. "Female Leaders Are Disrupting and Challenging These 5 Sectors." *Forbes*. May 20, 2021. https://www.forbes.com/sites/serenitygibbons/2021/05/20/5-female-disruptors-who-are-evolving-their-industries/?sh=72e867ad5593

Goleman, Daniel. *Emotional Intelligence*. New York, New York: Random House Publishing. 2005.

Grant, Adam. *Originals*. New York, New York: Viking. February 2, 2016.

Howard, Caroline. "Disruption Vs. Innovation: What's The Difference?" *Forbes.* March 27, 2013.

https://www.forbes.com/sites/ carolinehoward/2013/03/27/you-say-innovator-i-say-disruptor-whats-the-difference/?sh=72cbf7916f43

Kazakhstan Astana. "Kazakhstan: Prime Minister Briefs Boehner Codel on Economic and Energy Issues." WikiLeaks: Public Library of US Diplomacy." August 10, 2009.

https://wikileaks.org/plusd/ cables/09ASTANA1365_a.html

Lawrence, Jeffrey. "Who Owns Your Academic Community?" *Chronicle of Higher Education.* March 1, 2022.

https://www.chronicle.com/article/ who-owns-your-academic-community

Liszt Academy. Árpád Szendy.

https://lfze.hu/notable-alumni/szendy-arpad-1715

Lynch, Kevin. "10 great innovators – and what made them great." *Tech Radar.*

September 27, 2018.

https://www.techradar.com/ news/10-great-innovators-and-what-made-them-great

Microsoft. "Inclusion is Innovation: Women Community."

https://news.microsoft.com/inclusionisinnovation/ women/

Pepitone, Julianne. "Meet Haben Girma, the deafblind woman who conquered Harvard." *NBC News.* August 9, 2019.

https://www.nbcnews.com/know-your-value/feature/meet-haben-girma-deafblind-woman-who-conquered-harvard-ncna1040916

Shonk, Katie. "Power in Negotiations: How to Maximize a Weak BATNA." *Program on Negotiation Daily Blog.* February 17, 2022.

https://www.pon.harvard.edu/daily/batna/in-dispute-over-avengers-age-of-ultron-disney-faced-weak-batna/

Wai, Jonathan. "Seven Ways to Be More Curious." *Psychology Today.* July 31, 2014.

https://www.psychologytoday.com/us/blog/finding-the-next-einstein/201407/seven-ways-be-more-curious

World Intellectual Property Organization. "Gender Gap in Innovation Closing, But Progress is Slow." March 8, 2021.

https://www.wipo.int/women-and-ip/en/news/2021/news_0002.html

Yu, Alisa, Julian Zlatev, and Justin Berg. "What's the Best Way to Build Trust at Work?" *Harvard Business Review.* June 18, 2021.

https://hbr.org/2021/06/whats-the-best-way-to-build-trust-at-work

About the Author

Marcia-Elizabeth C. Favale is an experienced CEO, entrepreneur, and a U.S. patented tech inventor. Marcia founded Blingby, an interactive mar & adtech solution focused on narrative design and minimizing search friction, among others. Marcia was named a "Top Female Founder to Watch" by Tech:NYC.

She has an illustrious career in finance (investment banking and portfolio management) and has created a restructuring international benchmark (financial institutions). She is also the subject matter of a Saïd Business School-University of Oxford-Case Study and featured in online courses in Women's Leadership and Alternative Investments. Marcia teaches on the Msc MMPM and is guest lecturer (private equity) at Saïd Business School (Oxford). Her advisory firm was ranked alongside UBS and Lazard as "CEE Restructuring Firm" by *Euromoney Magazine*. Marcia was ranked by *Institutional Investor Magazine* as the "Top Analyst for Emerging Market Corporate and Research."

Marcia is also the author of *Risk, Recovery, and Empowerment: The Kazakhstan Bank Restructure Case Study*.

Printed in the USA
CPSIA information can be obtained
at www.ICGtesting.com
CBHW030530070724
11196CB00022B/139/J